THE STORY IN A PICTURE

Animals in Art

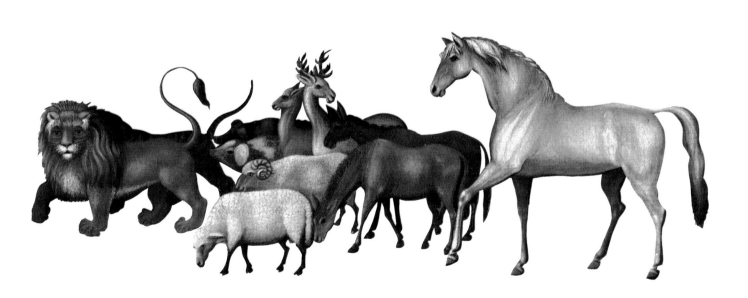

For Maya Rebecca Aitken,
with love

Front cover artwork: **Noah's Ark**, Edward Hicks. Courtesy of the Philadelphia Museum of Art. **Yakima Beaded Bag**, Plateau Beadworkers. Courtesy of The Thomas Burke Memorial Washington State Museum, University of Washington, Seattle. **Two Carp (Year of the Hare)**, Katsushika Hokusai. Courtesy of Musée National des Art Asiatiques-Guiment, Paris. **Akbar Hunting with Cheetahs near Agra**, Outline: Basawan/Painting: Dharm Das. Courtesy of the Trustees of the Victoria and Albert Museum.

Back cover artwork: **Two Cats on a Kelim**, Elizabeth Blackadder. Courtesy of the Artist/Hove Art Gallery. **Sheep With Lamb I**, Henry Moore. Courtesy of The Henry Moore Foundation.

Title page artwork: **The Forest Tapestry**, William Morris. Courtesy of the Victoria and Albert Museum.

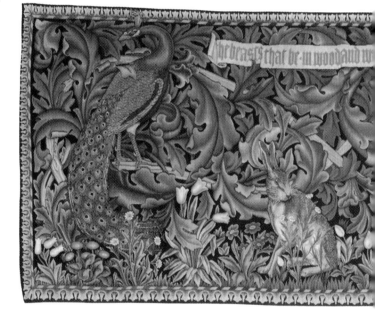

Text copyright © 1993 by Robin Richmond
Illustrations copyright © 1993 by individual copyright holders

Published by Ideals Publishing Corporation
Nashville, Tennessee 37214

Printed and bound in the United States of America.

Library of Congress Cataloging-in-Publication Data is available.

ISBN 0-8249-8613-X (trade)
ISBN 0-8249-8626-1 (lib. bdg.)

The display type is set in Garamond Swash.
The text type is set in Garamond.
Color separations made by Precision Color Graphics,
New Berlin, Wisconsin.
Printed and bound by Arcata Graphics, Kingsport, Tennessee.

Created and designed by Treld Bicknell.

First edition
10 9 8 7 6 5 4 3 2 1

THE STORY IN A PICTURE

Animals in Art

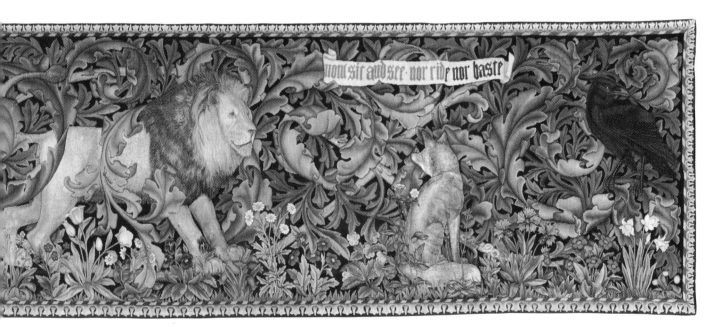

by
Robin Richmond

Ideals Children's Books • Nashville, Tennessee

CONTENTS

INTRODUCTION

As you walk through an art museum or gallery, you often see that the paintings are arranged on the walls according to the date, or period, and the country in which each was painted. Sometimes there are even signs directing you to the next paintings in the series. This helps you to understand how painting has developed and changed throughout its long history. But it certainly isn't the only way to look at art.

If you think of this book as a miniature museum, you will see that I have organized it in a different way. For my museum I have picked out paintings that are all about the same subject. My museum is filled with paintings from all over the world, from Australia to Alaska. Few museum directors are so lucky!

Many people—not just children—are puzzled by art. It seems so complicated, and it is hard to know where to start. Looking at one subject at a time makes it easier to understand what the artist is doing. I have chosen a theme for my museum that will be very familiar to you—animals—so you already know that you will be looking at creatures very like your own pets, or like the animals you have seen in zoos and wildlife films.

Almost everyone has a favorite animal

or a pet that delights and amuses them. Like most artists, I work by myself in a studio. I would get very lonely were it not for my wonderful Siamese cat, Sammy, who keeps me company when I'm painting and writing. The artist Gwen John, whose portrait of her cat is on page 28, was a person who loved solitude but found great happiness in the company of her animal friends. Look at the languid expressions of the faces of Carpaccio's Venetian ladies (page 30). As they take in the evening air on their terrace, they are accompanied by their little dogs, who provide them with enjoyment.

Some of us have pictures in our minds of what life in the wild is like or of the animal that most fascinates us—even though we may not have seen it in real life. I know that my daydreams are more often about unicorns (page 19), tigers (page 38), and elephants (pages 32 and 46) than about more familiar animals. I am fascinated by the huge, ungainly creatures that seem to belong to another age, before man, when the earth was the kingdom of animals. Even the rhinoceros is so strange and unusual, it now seems like a relic from the age of dinosaurs.

Artists sometimes put animals into their pictures for interesting reasons. An animal

in a picture can tell us many things about what it is like to be a human being. You will find paintings of animals in this book that represent every human emotion—sometimes without a person in sight. Like everyone else, artists have feelings of intense happiness and profound sadness, but they are lucky enough to be able to express and channel these feelings into their art. In a religious painting like Grünewald's melancholy 16th-century Issenheim Altarpiece (detail, page 22), the gentle lamb stands for, or *symbolizes*, the suffering of Christ on the cross. Grünewald tells us a story of sacrifice and grief in his picture by using an animal that we recognize immediately. Van Eyck puts a friendly little dog into his portrait of the Arnolfini marriage (page 18). The loyal little animal stands for loyalty and faithfulness in people, and bodes well for the newly married couple.

When a painter uses symbolism, he or she is using a kind of code. Picasso's masterwork *Guernica* (page 34–35) shows us the brutal suffering of animals in war to tell us a dramatic story about the inhumanity of people to one another. Animals may fight, but war is a human invention.

In Sir Edwin Landseer's comical portrait of two pet dogs (page 27), the artist's aim is much more lighthearted. The patient spaniel and the mischievous terrier show us different aspects of human personality in one happy scene.

Some of the paintings in this book are about exactly what they seem. Léger's cow (page 10) is simply the jolliest cow that I've ever seen in art. It bounces across the picture in a zany burst of spring fever. The French have a wonderful expression—"to feel good in one's skin." It seems that Léger truly felt good in *his* skin when he painted this picture. Not to mention the dancing cow!

In the Egyptian papyrus (page 37), an unknown artist—working over 1,000 years before the birth of Christ—is as full of fun as Léger. The lion and antelope play their game of senet as though they were competing for the world chess title and a large cash prize!

There may be some pictures in this book which look strange to you. Many have been made from odd-looking materials. They were not created as paintings in the ordinary way—but as woven tapestries, cutouts, or button and bead pictures. Like a lot of modern painting, they try to express the artist's feelings, rather than showing us how the world looks. But every picture has a story to be told, and I want to tell you these different stories.

Artists are not always very good at talking about their work, or even about other people's work, because art is not about words, but about *looking*. It's hard to put into words what you feel when you look at a picture, and that is the most magical thing about art. A picture can make you feel happy and excited, or gloomy and sad—and there's no need to explain these feelings. Sometimes a picture is confusing and strange, but knowing something about the artist's life will help you to understand and appreciate the painting.

I am an artist. But I know that what

I. ANIMALS IN NATURE

happens in my life as wife, mother, sister, daughter, teacher, or friend also influences my work.

This book, like its predecessor, *Children in Art,* begins with one of my own pictures. I will try to explain what made me paint the picture and how I painted it as honestly and clearly as I can. Together we will look at the work of some of the world's greatest artists and try to see what animals meant to them in their work.

Look at the paintings in the book several times and think about them. Then when you get the chance to visit them in museums and galleries, it will be like visiting an old friend.

Robin Richmond

Black, 1990
ROBIN RICHMOND

I HAVE AN OLD FRIEND NAMED MICHAEL WHO lives in the country. His old cottage looks like an illustration from Hansel and Gretel—all lopsided and rickety, with moss growing on the gabled roof. It sits in a patchwork quilt of fields, and Michael often sits on his terrace and gazes out over the luscious green toward the Isle of Wight, a tiny island in the English Channel. When I go to visit Michael in springtime, we have a ritual. We walk together across the fields and down to the bluebell woods. On the way, we admire the primroses, and cast a private spell over these delicate yellow flowers, hoping that no one will pick these rare and protected plants.

Sometimes we see wild ponies that freely roam the New Forest—the last of England's ancient forests. The ponies are often very shy of people. They are ragged and their fur is full of brambles and knots. But they are healthy, and they are protected by the law, just like the primroses. The ponies whinny and rear at the approach of humans, but they are content to forage in the hedgerows if left in peace.

The lumbering cows are different. They

come up very close to us, eager for a look at these trespassers on this ancient land. The cows stand almost motionless, transfixed with lazy curiosity, their only movement a rustle from one heavy hoof to the other. They seem almost like prehistoric creatures—very wise and calm.

For many years, I thought about doing a painting of these cows. I wanted to understand their odd grace. Their mysterious gaze troubled and pleased me at the same time, because I realized that I couldn't really see their eyes. You can see in the picture that, although the cows seem to look right at you, there are no eyes.

I also wanted to try and paint their velvety blackness. Black is one of the most interesting colors for an artist. Most people think that making the color black is quite straightforward and easy. You probably think that if you just squeeze it out of the tube, you will have a convincing black. Not exactly. Plain black can look hard and sharp when used on its own. The black of a cow's hide is rich and deep, and the fur catches tiny points of light. All the best blacks in painting, like the sagging folds of the rhinoceros's hide in the 18th-century painting by Pietro Longhi (page 36), are made from mixing many colors. Small amounts of brilliant orange, deep blue, and a smidgen of purple give pure black a depth that seems to reflect some light. In the background behind the cows, I have made wild, colorful woods to set off the black of the animals.

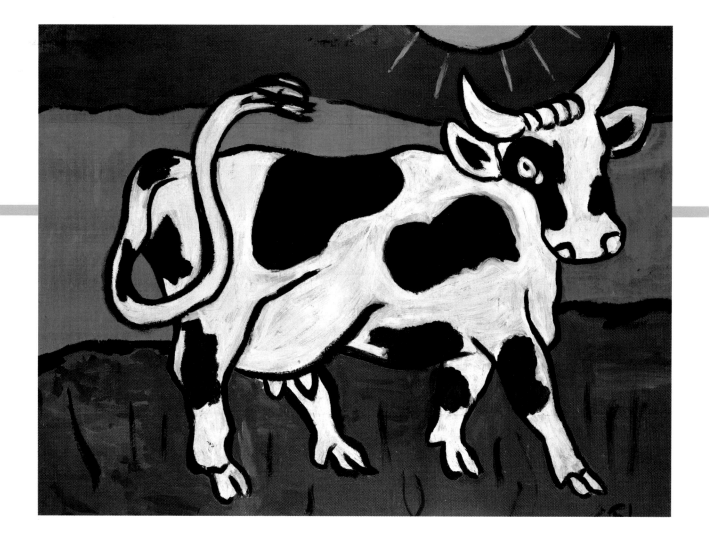

The Cow
FERNAND LÉGER

THIS COW IS MUCH JOLLIER THAN MY brooding animals on the previous page. The artist, Fernand Léger, has made this heavy, somber creature dance merrily in the glory of the noonday sun. She looks just like the "cow who jumped over the moon" in the nursery rhyme.

This is a very lighthearted picture by an artist whose work is much more often about the energy of machines and the abstract pleasures of geometry. How sad that Léger died in 1955. He probably would have loved the age of computer graphics!

Sheep With Lamb I, 1972
Sheep in a Field, 1974
HENRY MOORE

"Drawing is everything. If somebody comes to me and says there is a young sculptor and he is going to be very good—would you like to see his work? I say: What's his drawing like? Oh, he doesn't draw. Well then, I know he's no good."

Henry Moore, in conversation

HENRY MOORE IS PROBABLY THE MOST famous, and certainly the best-loved, British sculptor of the 20th century. His huge statues can be seen in museums and public spaces all over the

world. I passed by one of them every morning during the five years I spent as an art student in London. He had founded the sculpture school at the school I attended and had been Professor of Sculpture thirty years before I arrived. But his influence was strong and his views on drawing were still followed—we all had to draw and draw and draw!

Most of Moore's work is based on the human figure, but he was interested in every aspect of the world of nature. When forced to leave his London studio during the heaviest days of bombing in World War II, Henry Moore moved to the country. He drew upon this experience during his long career. The bumps and hollows of stones and rocks, the craggy elegance of trees, the wide Hertfordshire skies, and the bleached bones of dead animals all influenced his sculpture.

Moore couldn't remember when he began to draw the sheep that grazed in the field outside his studio windows. He said that he grew to recognize each, with its own individual face and personality:

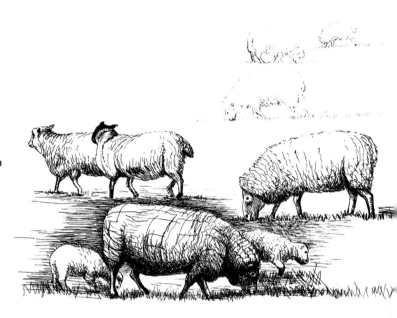

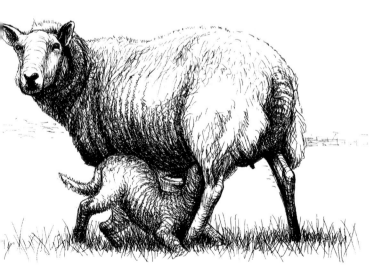

"Some were thin and elegant, and some were fat and lazy."

These drawings are actually *etchings.* Etching is a technique that enables an artist to make many copies of one drawing. The artist draws on a specially prepared *plate* of copper. The lines are etched in a bath of acid and become almost permanent. The plate is inked, and paper is placed over it. A heavy weight is rolled over both, which transfers the drawing from plate to paper. Look at Hokusai (page 12); he is a printmaker as well.

Sheep are wonderful subjects for drawing and etching. Their bodies look like plump pillows on a sofa and their heads and legs are fine and sensitive. Henry Moore described them as "wool with four legs," but he has made them much more interesting than that. In the drawing of the nursing lamb, the worried mother stares out at Moore, and you might feel that she is warning him, "Come any closer to us and I'll get you!"

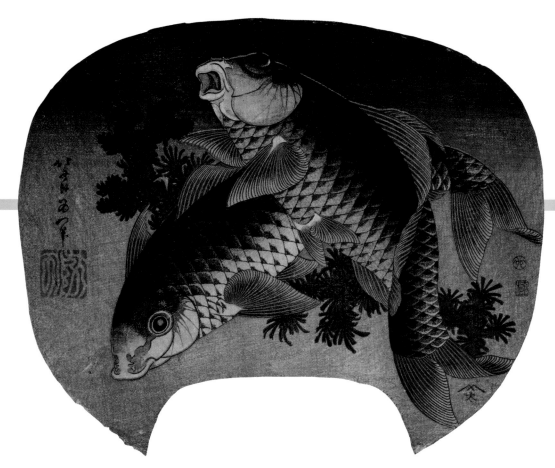

Two Carp (Year of the Hare), 1831

KATSUSHIKA HOKUSAI

I N JAPAN, THE CARP SYMBOLIZES STRENGTH and perseverance. The carp's life is said to be magical and important, surviving many trials. According to the teachings of ancient Eastern religions, carp were capable of many astonishing feats: leaping up waterfalls; swimming the Yellow River; passing through the Five Cataracts; crossing through the magical Dragon's Gate; and, at last, becoming mystical dragons. Even today, during the Boy's Festival in May, brightly colored kites and streamers depicting carp are hung outside Japanese homes.

This picture is an odd shape because it was actually used as a fan. The fish, water-weeds, and seal were carved into a thin block of wood, which was carefully inked with two colors—brown and blue— and pressed firmly onto soft paper in a printing press. This form of printmaking is called wood-block printing and was perfected by Hokusai in Japan in the early 19th century.

Hokusai is most famous for his book *One Hundred Views of Mount Fuji,* but he also hand-printed many wonderful volumes of prints. His work became famous throughout the world when French artists discovered it nearly half a century after his death. They rushed to buy Hokusai's beautifully designed prints, along with other Oriental arts and crafts, from a small shop in Paris called *La Porte Chinoise*, which means "The Chinese Door." Hokusai's work was greatly admired and has had a strong influence on painting and the graphic arts.

Metamorphosis of a Frog, late 17th century

MARIA-SYBILLA MERIAN

MARIA-SYBILLA MERIAN WAS THE most famous female painter of natural history subjects in the 17th century. In her time, women were not thought capable of making an important contribution to the history of art. Their male colleagues discouraged them from attempting to paint religious or historical subjects—nature painting was considered more ladylike. Maria-Sybilla, like so many women artists from earlier times, learned her craft from her father, Matthaus Merian, a famous German engraver.

This painting uses watercolor on *vellum* rather than paper. Vellum is parchment made from very finely cleaned calfskin. It takes great skill to paint on vellum, because it crinkles up when it gets too wet. It also turns yellow when exposed to light, so museums keep the lights very low when displaying this sort of work. Le Sueur (page 14) also painted on vellum.

From an early age, Maria-Sybilla was fascinated by plants and insects, and she amazed her family with her brilliant drawings of living things. In 1698, she left her husband and set off into the unknown, uncharted forests of Surinam in South America with her daughter Dorothea. The result of this brave expedition was a classic book of detailed drawings of the insects and animals of Surinam.

If you look very carefully at this picture, you will see the whole life cycle of the frog. If you've ever kept frogs in your classroom at school you will recognize the frog spawn and tadpoles in minute detail at the foot of the painting. In the middle of the picture, you can see the tadpoles growing bigger, their tails getting more vigorous as they begin to develop tiny legs. Toward the top, the tadpoles have developed into baby froglets, and at the *very* top is a mighty frog in all his spotted glory. The frog on the bottom is about to eat a bug. Look at that expression of greed!

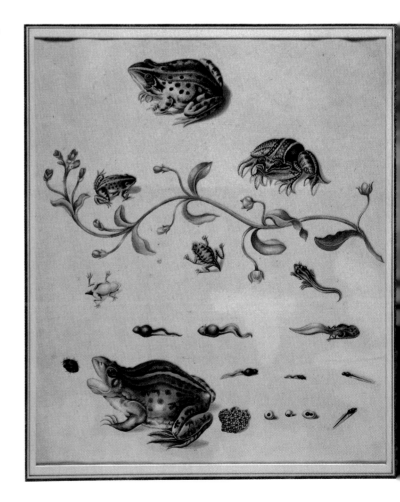

Chrysaora Lesueur, early 19th century

CHARLES ALEXANDRE LE SUEUR

MANY EUROPEAN EXPLORERS WERE inspired by Captain Cook's famous expeditions to the South Seas in the 1770s, and they followed in his wake. Artists were also fascinated by the new life forms discovered on these journeys to the Pacific, and they became important members of the crew on later voyages. Their job was to record the plants *(flora)* and the animals *(fauna)* that were discovered.

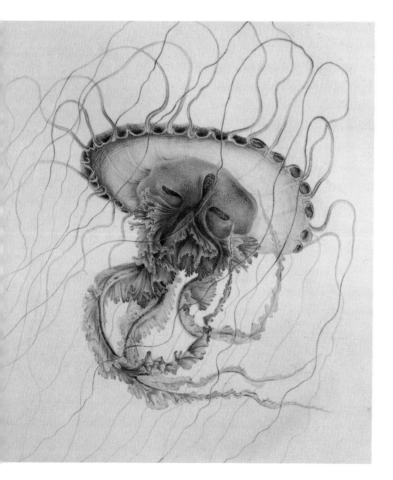

Charles Alexandre Le Sueur was the assistant helmsman on the good ship *Geographe*. Captain Nicolas Baudin's trained artist fell ill, and Le Sueur and Nicolas Petit, an assistant gunner, were assigned the task in his place. Also on board was the naturalist François Peron, who recorded in his log: "All our work, all our observations derived from living animals, in the presence of all the superior officers of our ship, who will vouch for the care we took with them." Le Sueur's job was to stuff the specimens they found, as well as to record them in paintings.

Jellyfish were Le Sueur's favorite animals. I can't imagine this because I associate them with painful surprises when I swim in the ocean, but I must admit they are very beautiful. Their fragile, transparent bodies and their wispy tendrils seem to be weightless. Biologists have discovered that jellyfish are very primitive animals, but they appear to be very complicated. You can tell from this picture of a jellyfish (named after Le Sueur himself, who discovered it) that Le Sueur actually observed and sketched it floating alive in the water. His final painting of the subject, on vellum, was probably created when he returned to France. The jellyfish is so natural-looking that it appears it could give us a nasty sting almost 200 years after it was painted!

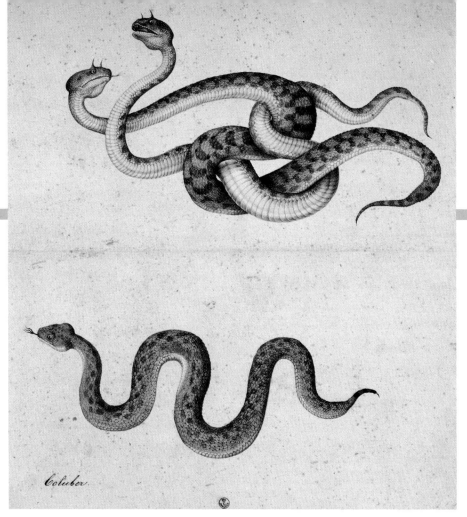

Horned Vipers and Avicennes Viper, 16th century

JACOPO LIGOZZI

AT THE END OF THE 14TH CENTURY, THE Florentine nobleman Cosimo de' Medici, a member of one of the richest and most powerful families in Renaissance Europe, created the first museum of natural history. It was really just a room filled with samples of minerals and stuffed animals from faraway places. Today it might look silly to us, but in its time, it was a magnificent display. Cosimo's descendant, Francis de' Medici, kept up the collection; and while in Francis's employ, the Veronese artist Jacopo Ligozzi painted over 314 studies of plants and animals for the museum.

Ligozzi was both a diligent scientific observer and an expert artist.

Ligozzi was able to make a painting interesting while telling us more about a killer animal than we might really want to know. Vipers are highly poisonous snakes, and a bite can be fatal. This picture shows two different species of viper on one page of a book. Ligozzi makes the snakes in the top picture look even more vicious than they actually are by painting their bodies intertwined, their deadly tongues darting dangerously, and their heads rearing up as if to bite each other in a fatal embrace. Look at the detail of the painting—every scale and speckle is carefully rendered. You can almost feel the dry, sinister scales of these creatures wrapped in their deadly "love knot."

Paleolithic Cave Painting: Horse, 15,000 B.C.

LASCAUX, MONTIGNAC, FRANCE

ONE DAY, IN ABOUT 1940, A YOUNG man named Marcel Ravidat went for a walk in southwest France with three friends and his little dog, Robot. They were bored and looking for adventure. They had heard rumors of a lost tunnel that led to the old manor house of Lascaux. As they searched for the tunnel, they took turns throwing a rubber ball for Robot.

Suddenly, Robot disappeared. Thinking that he was searching for the ball, the friends weren't worried. But as time passed and he didn't come back, they became concerned.

Then they heard the faintest of barks. They followed the sound and discovered Robot at the bottom of a hole. The little dog was safe but frightened because a dead donkey lay next to him.

Marcel rescued his dog from the hole, but when he tried to shift the dead donkey, he discovered another very deep hole underneath it. He decided to go home and come back another day with the proper tools and a lamp.

Four days later, he returned with some friends. He tried to squeeze his body into the hole, head first. But like Winnie the Pooh, he became completely stuck. At last, after a lot of wriggling, he moved. Then he fell—deep into the earth—and was knocked unconscious.

When he came to, Marcel knew that he was in a very strange place. He lit his lamp and what he saw amazed him. It was a cave with other caves leading from it. The walls were covered with paintings of horses and deer, and men with strange, birdlike heads.

Marcel had made a great find. This wasn't a lost tunnel—it was one of the most important discoveries in the history of art. The caves of Lascaux contain some of the earliest known paintings. Scientists have dated them as being over 17,000 years old.

The artists of these great pictures were Paleolithic hunter-gatherers, who dressed in animal skins, used tools made of stone and bone, and probably lived not in caves, but in round tepee-like tents. We cannot be certain of the meanings of the pictures. They might be about hunting. They might be about magic, like the Eskimo painting on page 25. No one knows. But the power of the paintings is dazzling, and it is easy to see that the early painters of Lascaux were great artists. Their horses are as alive as the carefully observed studies by Stubbs (opposite).

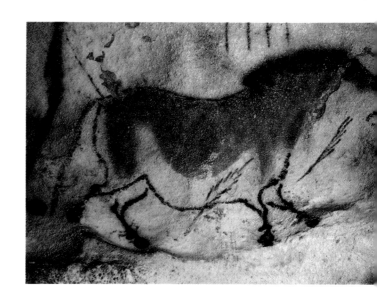

A Lion Attacking a Horse, c.1762

GEORGE STUBBS

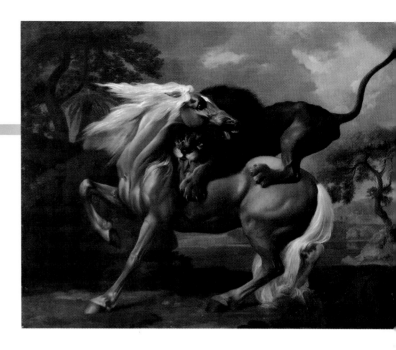

LIKE LIGOZZI, LESUEUR, AND MARIA-Sybilla Merian (pages 13-15), George Stubbs was fascinated by science, and he mixed this fascination with sensitivity and artistic excellence. After working for a time at his father's trade of saddle-making and leatherworking, his love of drawing and painting led him to try the uncertain life of an artist. He made a detailed study of horses and published his classic book, *The Anatomy of the Horse*, in 1766.

The Paleolithic painters of Lascaux (opposite) had an equally profound understanding of the horse, which was based on watching wild horses as they ran and attempting to express what it feels like to ride a horse. Their drawings are wild and free and full of energy. Stubbs's anatomical studies of horses, on the other hand, allowed him great intellectual understanding of their movements.

The theme of a lion attacking a horse worried Stubbs for over thirty years. He used his profound knowledge of a horse's movement and muscles to express its terror, as it stretches its neck back over the head of the lion. This picture is the largest of seventeen versions of the same horrific subject. It is enormous. The receipt for the picture, painted for the Marquess of Rockingham at a cost of eighty guineas (about $400 in the 1760s—a considerable sum), says; "Eighty guineas for one Picture of a Lion and another of a horse as Large as Life."

No one knows where the idea for these pictures came from. Possibly Stubbs saw an ancient Greek or Roman statue of the subject during his visit to Rome in 1754. Possibly the drama and ferocity of the subject inspired him to contemplate this image of the cruelty of nature. Unlike Rousseau (page 38), who based his paintings of wild animals on photographs, Stubbs drew the lion—as well as the horse—from living creatures. A friend of Stubbs recounted:

"The studies . . . were made from a Lyon (lion) of Lord Shelbourne's at his villa on Hounslow Heath, by the permission of his Lordship's Gardner (gardener). The Lyon was confined in a cage, like those at the Tower of London."

Judging by the anger we see in the lion's eyes, and the sharpness of his claws, this was a good thing.

II. ANIMALS AS SYMBOLS

The Arnolfini Marriage, 1434
JAN VAN EYCK

THIS PAINTING COMMEMORATES THE marriage of the Italian merchant, Giovanni (known as Jan) Arnolfini and Giovanna Cenami in Bruges in 1434. The city of Bruges was the capital of Flanders, in a country now called Belgium. Bruges was the center of the cloth-making and banking world in 14th- and early 15th-century Europe. Many successful Italian businessmen and their families lived there.

Van Eyck was the greatest Flemish painter of this period, sought after by wealthy patrons including Philip, Duke of Burgundy, and Count John of Holland. Many scholars believe that Van Eyck invented the new technique of oil painting. But if invented is too strong a word, it is certain that Van Eyck perfected the use of oils—achieving a brilliant, lasting, glowing color in his work.

This painting is mysterious for many reasons, and historians disagree about its inner meaning. Is Giovanna pregnant or is she just holding up the heavy folds of her gown to make her belly look plump, a sign of beauty in Flanders? Who are the two men we glimpse in the convex mirror on the far wall? Why is the little dog looking straight at us while the two people look away? Why is there only one candle lit in the magnificent chandelier? Artists often place and position things in their pictures to give us extra information. These clues are called symbols. Van Eyck wants us to think about the symbols in his painting.

In fact, Giovanna is not pregnant, but the artist is telling us that she wants to have children in the future. The two men

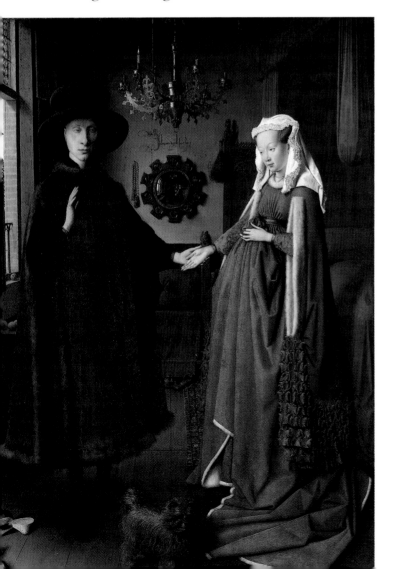

in the mirror are the witnesses to the marriage. The man in blue is probably Van Eyck himself—he has testified to his presence by stating in elaborate script: "Johannes de eyck fuit hic," (Jan Van Eyck was here) in Latin, the language of scholarship. The little dog represents faithfulness, and looks straight out at us to emphasize this aspect of marriage. The artist is saying that the two young people will love each other in the future with absolute trust and faithfulness.

The Lady and the Unicorn, 1500

ARTIST SEAMSTRESSES UNKNOWN

THIS PICTURE WAS NOT MADE WITH brushes and paint but with needles and thread, like the *Forest Tapestry* (page 40) and the *Button Blanket* (page 42). *The Lady and the Unicorn* is a sewn tapestry and was created by a group of women working together. The picture is made of thousands of tiny diagonal stitches pulled through the holes of a loosely woven canvas. It is a very time-consuming way to make a picture, but many consider it restful and enjoyable.

With only an open fire for heat and candles for light, the women sat together in a freezing room in a French castle. While they passed the hours in companionable conversation, these aristocratic ladies of the court created an object of both magical beauty and practical usefulness. Tapestries were used to keep the chill winds of winter from whistling through the cold stone walls of the castles, or *chateaux.*

The image of the unicorn is very special, for this beast—whose name means "one horn"—exists only in myths and fairy tales. The noble young woman in the picture is about to be married, and the unicorn is an ancient symbol of pureness of heart. The lion is also a symbol, one of the many used by artists to stand for Christ (see pages 20, 22, and 23). At the time this tapestry was made, lion cubs were thought to be born dead until their fathers breathed life into their faces, thus they symbolize the death and Resurrection of Christ.

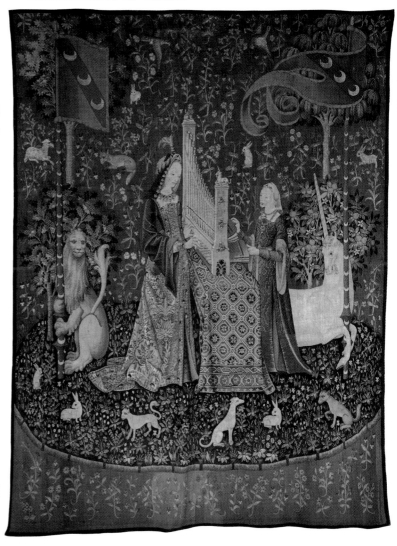

The Vision of Saint Eustace, 1440

ANTONIO PISANO (PISANELLO)

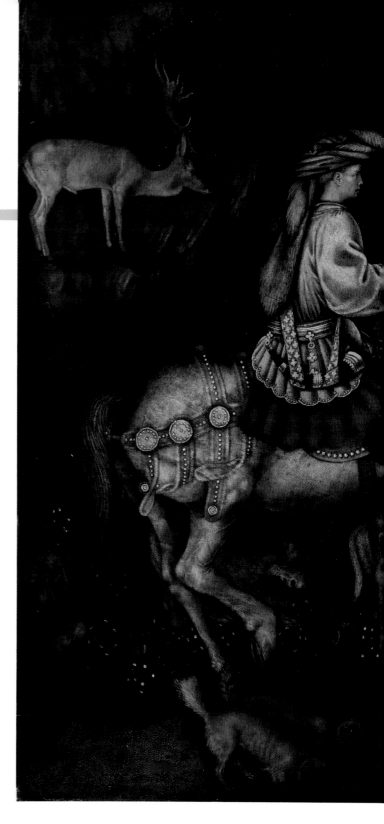

AT FIRST GLANCE, THIS PICTURE SEEMS to be about a wealthy young Renaissance nobleman hunting in the deep forest, surrounded by his faithful dogs. But if you follow the rider's gaze and look closely at the stag, you can see something very strange. Between the beast's antlers is a crucifix, a statue of Jesus on the cross.

The legend of St. Eustace tells of a general in the army of the Roman Emperor Trajan, who went hunting in the forest near Rome. As he rode through the forest he came upon a stag. He was about to kill the animal when, to his astonishment, he noticed an image of Christ on the cross glowing eerily and balanced on the head of the stag.

Like his emperor, the young general worshiped a variety of pagan gods, but his mystical experience in the forest changed his life forever. He became Christian but was punished for his beliefs by the Roman state. He suffered poverty, disgrace, and death. He was supposed to have been burned alive! After his death, the young man was named St. Eustace by the Roman Catholic church, and his feast day is celebrated on September 20.

In Pisanello's picture, the only sign of drama is the young man's raised right hand. The miraculous stag is only one of many animals in the picture, which makes the miracle seem a natural event. The dogs at St. Eustace's feet take no notice.

The storks in the air, the bounding hare, the bears curled in the mossy, dark forest have no interest at all in the event that changed a young man's life.

Pisanello painted in a decorative style called International Gothic, developed in the late 14th century. With his master

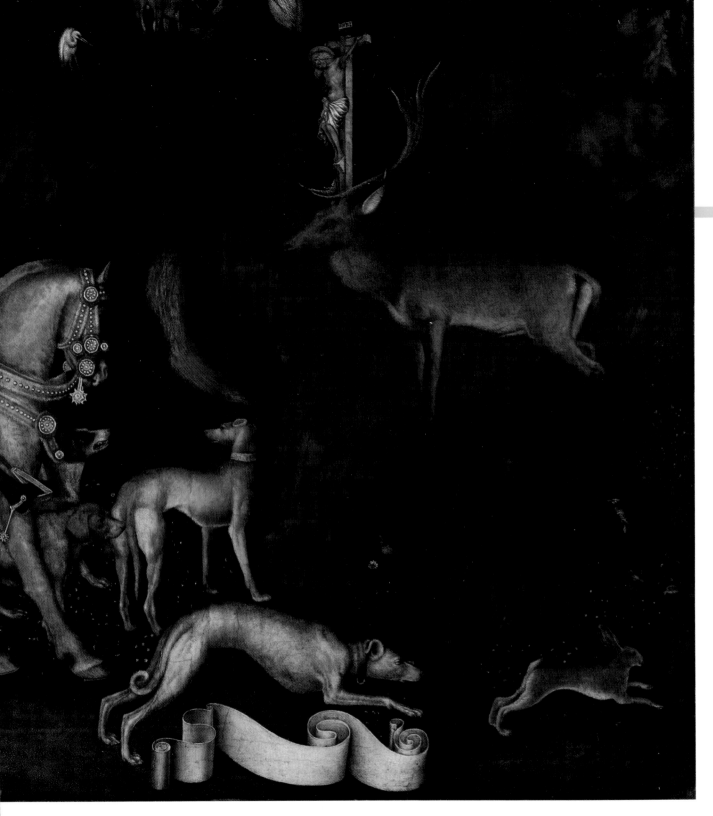

Gentile da Fabriano, Pisanello loved to celebrate tiny details of nature in his painting, bringing a lively, new realism to the more solemn art of the Middle Ages. The symbolism used by the artist is significant. It makes an interesting comparison with Holman Hunt's use of the goat (page 23), and Grünewald's lamb in the altarpiece (page 22). By making a connection between Christ and the stag, the king of the forest, Pisanello tells us that this picture is about the nobility of Christ's sacrifice, and that of the brave young general who became St. Eustace.

The Crucifixion, (detail) from the Issenheim Altarpiece, 1510–1515

MATTHIAS GRÜNEWALD

IN THE PAINTING BY PISANELLO (PAGES 20-21), the Italian artist used a noble stag, glowing magically in the forest, to stand as his symbol for Jesus Christ. Holman Hunt (opposite) uses an old, battered goat, scratching in the parched desert as a symbol to show his particular view of Christ as a victim of human weakness and misunderstanding. The German painter Grünewald has a very different idea about the meaning of Christ's life and death. His vision is altogether darker and more tragic than either Pisanello or Hunt. Grünewald shows the sacrifice of an innocent lamb in his painting—symbolizing Jesus Christ, often called the Lamb of God.

This is a tiny section, known as a *detail,* from a very large and magnificent folding painting designed to stand on the altar of a church. The altarpiece is composed of ten paintings which change as the panels are opened and closed. It is one of the most extraordinary religious paintings in the world. Whether Christian, Jewish, or Muslim—whether you have any religion or none—the depth of feeling in Grünewald's great work is deeply moving. Grünewald's painting of the death of Christ on the cross, known as *The Crucifixion,* is equally moving. In the panel from which this detail has been chosen, Grünewald has painted an agonized Christ with blood running down his tortured body. The mild, little lamb standing at his feet is a symbol of innocence for the artist. The lamb bleeds into a goblet and holds a cross tucked beneath its right leg. This is intended to remind us of the sacrifice made by Christ on the cross. But Grünewald's vision of the crucifixion is heartrending, a long way from the triumph of St. Eustace's miraculous vision.

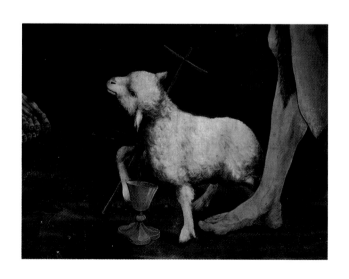

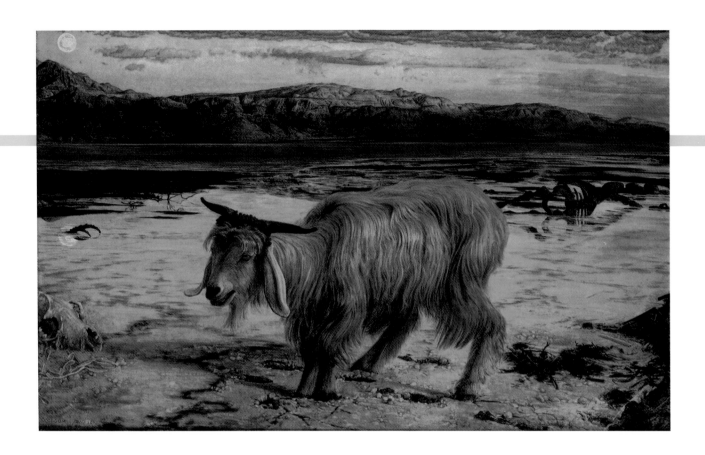

The Scapegoat, 1856

WILLIAM HOLMAN HUNT

THE PICTURES BY GRÜNEWALD (OPPOSITE) and Pisanello (page 20), and the *Lady and the Unicorn* tapestry (page 19) associate animals with religious subjects. Holman Hunt was a religious man too, and he painted many pictures from Bible settings. He actually traveled to the Holy Land, which was a very adventurous undertaking for a man of his time.

He was eager to see the actual setting of the Bible, and, with sketchbook in hand, he visited Palestine and Egypt. In this picture, he has painted a starved and thirsty goat desperately seeking nourishment in the salty wilderness of the Dead Sea. Hunt sees this lonely, miserable creature as a symbol of Christ, who fasted for forty days in the wilderness before he began preaching.

Christians believe that Christ sacrificed himself on the cross to save people from their sins. Hunt seems to be telling us that this old animal, bent with worry and woe, has been cast out of the world of people. Here the scapegoat, like Christ, will die to save humanity.

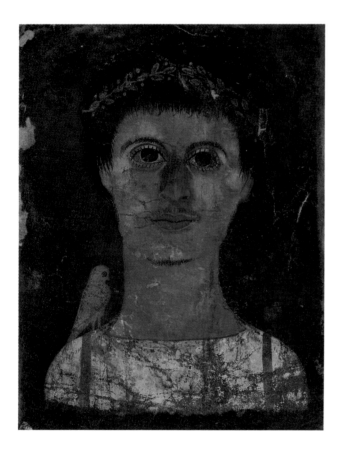

Mummy Shroud with Boy and Bird, early 4th century A.D.

EGYPTIAN, ARTIST UNKNOWN

IT IS SAD TO LOOK AT THIS PICTURE, because we know that when this picture was painted, the young man was dead. This is a mummy portrait. The ancient Egyptians believed in life after death, but unlike the papyrus (page 37), this picture was painted on a piece of linen material. It is called a *shroud,* and was used to protect the dead person's face. The small bird perched on the boy's shoulder is a little falcon. It symbolizes the Egyptian god Horus.

The Egyptians believed the falcon, soaring high above their heads in the desert sky, was a divine creature. They thought Horus the falcon contained the sun and the moon in his two gleaming eyes and that the dead boy would be protected in the next world by the presence of this little bird and the important god it represents.

Untitled (Flight of the Shaman), 1971

JESSIE OONARK

A SHAMAN IS A TYPE OF MAGICIAN OR medicine man. We might think of modern-day shamans as doctors, surgeons, or even scientists. Shamans are still very important in certain cultures today. I have a good friend in Arizona who calls himself a shaman and practices ancient tribal medicine. He has cured me of headaches with skills that he learned in South America, using medicine from wild plants and herbs.

In some societies, the shaman is thought to be able to heal the sick, predict and even change the weather, and bring a good day's hunting. The cave paintings at Lascaux (page 16) were probably painted 15,000 years ago by a shaman to ensure a successful hunt.

In Alaska the hunter-gatherers of the last Ice Age arrived from Northern Eurasia, traveling across a narrow stretch of land which used to be in the place of the Bering Strait. They brought their "shamanistic" religion with them.

This modern Alaskan picture shows a shaman, flying through space, accompanied by his animal helpers, or *familiars*. In Western fairy tales, the shaman is often a witch, usually accompanied by a cat as a familiar. The Alaskan shaman flies with the creatures of his arctic world—reindeer, sea gulls, and husky dogs.

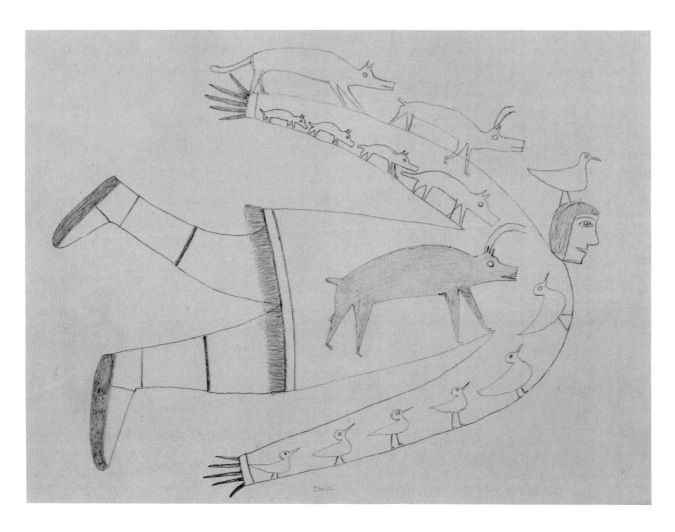

III. COMPANIONS

A Horseman in a Wood, 1850–1855

JEAN-BAPTISTE-CAMILLE COROT

SOME PAINTERS LIKE TO CAPTURE MORE than just the shape and movement of animals. They try to portray the unique relationship between people and their favorite animal companions. Corot's painting is a realistic and intimate portrait of horse and rider.

There are two carefully balanced themes in this picture. First is the relationship between man and animal, a harmony that is based on trust. The rider, Monsieur Pivot, rests his hand affectionately on the solid gray back of his mount—man and horse seem at one, trusting each other completely. They stand quietly together in a forest clearing and you can almost hear the small sounds of the rustling trees. It is a world away from the cruel grandeur of Stubbs (page 17).

The second theme is the effects of light, which clearly delights the artist. We know that the rider has paused in a forest clearing because the light falls sharply on his hat from above, leaving the trees around him in deep shadow. This French forest is filled with game, but today Monsieur Pivot enjoys a relaxing ride, rather than the thrills of the chase.

Corot is most famous for his light-filled and carefully composed landscape paintings. But the atmosphere of this friendly painting is more like his *pochades* —loose, informal sketches which fit into his *poche* (the pocket of his coat).

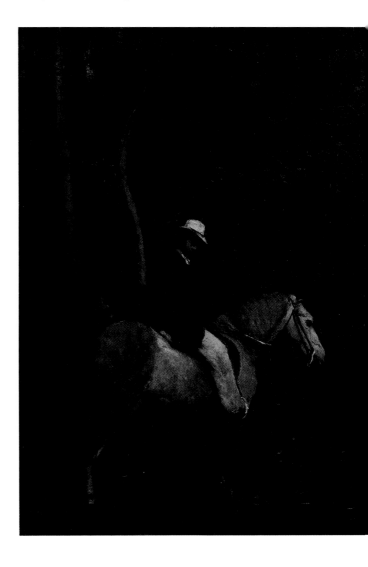

Dignity and Impudence, 1839
SIR EDWIN LANDSEER

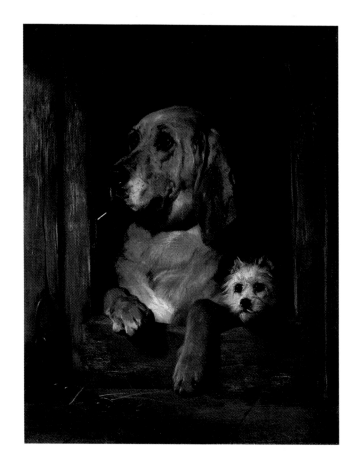

L ANDSEER WAS QUEEN VICTORIA'S FAVORITE painter. He painted her pet Cavalier King Charles spaniel, Dash, and Prince Albert's greyhound, Eos, many times as they sat in the regal lap of luxury. The queen rewarded the artist with a knighthood, and he became very wealthy and famous in his lifetime. The Victorians were very sentimental about animals, and they were Landseer's favorite subject for painting.

The Victorians believed (as many people do today) that animals are as important as human beings. In fact, the British joke that they love their pets as much as—or more than—their children, a joke which comes from this period.

The title of this realistic picture of an impudent terrier and a dignified hound is meant to remind us of human qualities. Which dog do you like better? I prefer Impudence, because Dignity looks like he's too careful and bossy. His left paw keeps beady-eyed Impudence from jumping out of their doghouse, when it is obvious that's what the terrier wants to do.

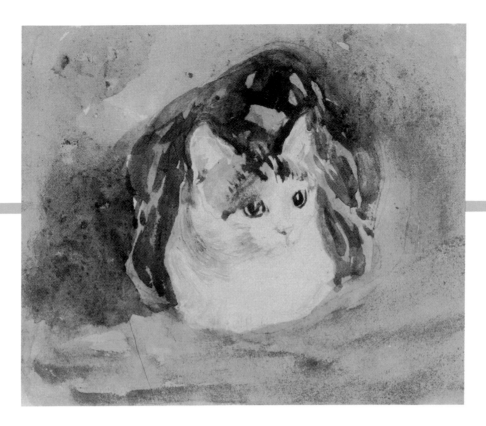

Cat, 1905–08

GWEN JOHN

"I paint a good deal, but I don't often get a picture done—that requires for me, a very long time of quiet mind . . ."

Gwen John

Gwen John wrote these words in a letter to a friend in 1910, and it says a lot about her modest personality and the quiet honesty of her art. Although Welsh by birth, she spent most of her life in Paris. It was a quiet life devoted to her painting and her cats. She never married and was a solitary, religious woman, although her circle of friends included some of the most famous painters, sculptors, poets, and philosophers of her time. The great French sculptor, Auguste Rodin, was the love of her life. She studied with the famous American painter James Abbott McNeil Whistler in Paris and knew the German poet Rainer Maria Rilke. Her neighbor in Meudon was the Catholic philosopher Jacques Maritain; they grew even closer when Gwen became a Catholic in 1913.

Gwen John's brother, Augustus John, was also a painter—as famous for his love of women as he was for his noisy, flamboyant pictures. His sister was, I think, a better painter. But Gwen John soon grew tired of the wild, undisciplined life of the Parisian art world, preferring the peace of her room where she developed her own intimate style of painting in solitude. She was soothed by the affection of her pet cats. This white-fronted tortoiseshell tabby was a great favorite, and Gwen John painted her often, until the cat mysteriously disappeared in 1908—a tragedy for her fond owner. There is such a lively expression of intelligence in the cat's eyes that you can almost hear the soft, lilting voice of the artist talking to her silent companion.

Two Cats on a Kelim, 1978
ELIZABETH BLACKADDER

MANY ARTISTS LIKE TO SURROUND themselves with richly textured materials and bright colors which inspire their work. Elizabeth Blackadder's home is full of kelims (flatly woven rugs from Morocco and the Far East), Persian rugs, embroidered cushions, gorgeous flowers, delightful miniature toys, inlaid boxes—and her beloved cats. My own studio is similar because I love patterns too.

Our family cat, Sammy, is an elegant and venerable sealpoint Siamese with turquoise eyes and chocolate-colored fur. And he often finds his way into my paintings. Elizabeth Blackadder uses her cats as the main subjects of many of her pictures.

Here, Coco, the tortoiseshell, and Benjamin, the Abyssinian, look out at us with the well-fed, slightly arrogant stare of animals who are truly loved. The burnt, autumnal colors of their fur are repeated in the leafy colors of the rugs.

Blackadder likes to make shapes in her work. Look at the rug on which her cats sit—it seems to fly up at us like a magic carpet. By tilting the rug upward, the artist shows us all of its geometrical shapes, which contrast with the jagged shapes of Coco's fur. Her white belly is the focus of the picture, and it gently guides our eye over to Benjamin's little white chin on the left. Coco looks alert. He seems to be surprised by the artist's rapt gaze and even slightly annoyed. Benjamin's slitty eyes are closing with boredom. There is a fascinating tension in this picture which comes from the different attitudes of the two animals.

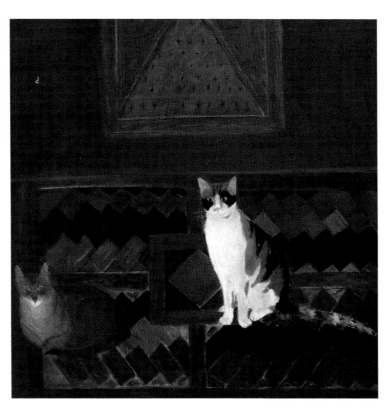

Two Venetian Ladies, c. 1515
VITTORE CARPACCIO

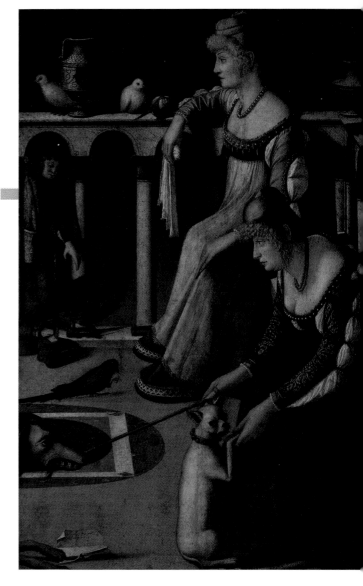

When Carpaccio was born in the 1460s, his native city of Venice was called the "pearl of the Adriatic Sea." The city was both beautiful and rich. Venice is an island city, criss-crossed with canals and set in a shallow lagoon, off the coast of Northern Italy.

In Carpaccio's time, Venice was the most peaceful city of importance on the Italian peninsula, safe from attack from the mainland. The city was very prosperous under its elected leader, known as the *Doge,* and the Venetian Republic was a model of successful government. The city's wealth came from trade, chiefly with the Far East. Marco Polo, the famous explorer, was a Venetian citizen who had so enjoyed a meal of spaghetti in China in 1260 that he brought back the recipe to Italy. It is funny to think that something so typically Italian should originally come from China!

Many wealthy citizens of Venice enjoyed spending their money on fine clothes, houses, and works of art. The two ladies in this painting look almost like twins and are typical upper-class Venetians, members of the Torella family whose noble crest decorates the clay vase. The women are enjoying the evening breeze on their roof terrace, away from the unpleasant sewage smell of the canals. A young boy amuses himself with the family pets. The women's gowns drip with pearls, and their collection of objects and animals demonstrates considerable wealth, giving us clues about the painting's meaning.

The fruit next to the vase is a pomegranate, an old symbol of both earthly love and religious belief. The handkerchief held by the lady in yellow is a love token from an absent admirer. The peacock is an ancient symbol of eternal life because it was once believed that its flesh never decayed. The dogs represent faithfulness, as in the Van Eyck painting (page 18), and the lady in red holds her tame little dog's paw, while he looks out at us as if to say, "Aren't I clever?"

IV. STORYTELLING

L'Arche de Noé (Noah's Ark), 1961–1966

MARC CHAGALL

" . . . he sent forth a dove from him, to see if the waters were abated from off the face of the ground but the dove found no rest for the sole of her foot, and she returned unto him into the ark, for the waters were on the face of the whole earth: and he put forth his hand, and took her, and pulled her into the ark."

Genesis 8: 8–10

NOAH'S STORY IS TOLD IN THE FIRST chapter of the Bible, called Genesis. God commanded Noah to build an ark and bring aboard one pair each of all the living creatures on Earth. The French painter Marc Chagall is famous for his vivid biblical pictures. They almost "sing" with wild, imaginative harmonies. All the rules of nature were ignored by Chagall. His people float happily in the sky, and horses fly as gracefully as doves.

Noah's ark is a wonderful subject for this artist, who painted it when he was seventy-four years old. His loose, almost childlike style of painting is perfect for the swirling blue waters surrounding Noah's flooded earth. The picture shows many members of the animal kingdom, such as donkeys, bulls, and fish. The ghostly people on the right symbolize the future generations of good human beings. Chagall is saying that these people will come back one day, after the flood, and they will wipe out the original sin of Adam and Eve. Noah is seen here in the moment when he releases the dove from his hand—a symbol of hope for all mankind.

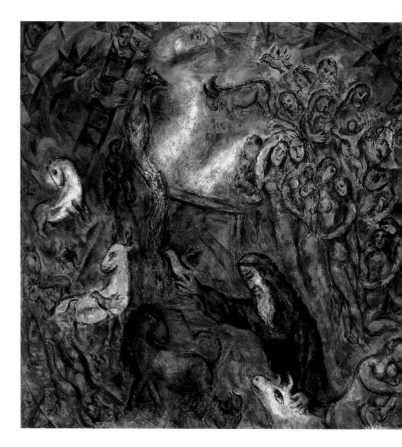

Noah's Ark, 1846

EDWARD HICKS

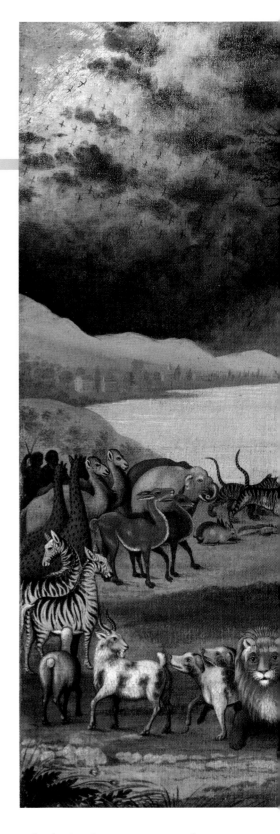

EDWARD HICKS WAS A SIGN PAINTER BY profession and a devout Quaker. He was such a religious man that in later life he became a preacher. The stories of the Bible were as rich a source of inspiration to him as they were later for Marc Chagall (page 31) in his very different and magical paintings. But Hicks treats the story of Noah and the flood in a much more literal way than Chagall, and in his painting, the Ark appears as a fine old Pennsylvania barn.

Hicks has clearly based his painting on a popular print by the famous 19th-century printmaker, Nathaniel Currier. The composition is nearly the same, but Hicks adds warmth and glorious color to the scene.

The animals are delicately portrayed with great affection and familiarity. Hicks was careful to acquaint himself as best he could with all his subjects and used animals—both domesticated and wild—in many of his paintings. The noble, prancing horses are very skillfully painted from Hicks's own observations, while the zebras, llamas, and elephants have the slightly exotic look of creatures drawn largely from the artist's imagination.

The lion is positioned in the center, staring out at the viewer with a direct, confident gaze befitting the "King of Beasts." He takes his place in the procession with pride and seems fully aware of his importance. The sheep instinctively use their last moments on land to graze.

Perhaps with their sharp senses, these trusting creatures know that the earth will soon become a terrible place of flood and disaster. The angry sky above the ark is

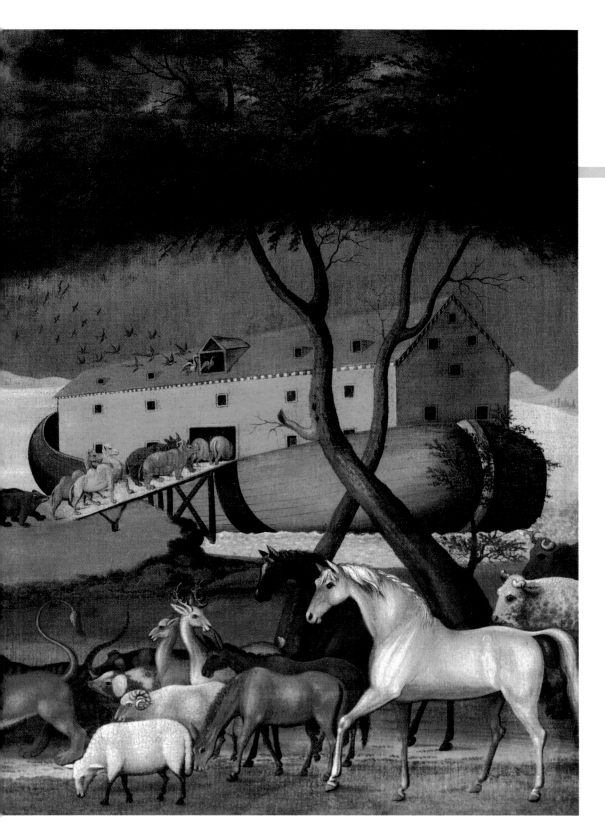

filled with birds flying away from their homes in the trees and into the tiny hatch in the roof of the Ark.

The small row of houses along the shore is not painted in the style usually found in grand biblical subjects, but as the plain Quaker homes from the artist's own beloved Newtown, Pennsylvania.

Guernica, 1937

PABLO PICASSO

THIS HUGE AND BRUTAL PAINTING DEPICTS the horror of war. It is about evil, and the longer you look at it, the more shocking the painting is. It was painted by Spaniard Pablo Picasso so that the world would never forget one of the darkest moments of the Spanish Civil War. It was painted while Picasso was in France and expresses all the pain of one who is far from his homeland. Picasso wanted the world to know of the evil created by Adolf Hitler in Germany and General Franco in Spain. The savagery of war—what Picasso called "a sea of suffering and death"—is apparent in every inch of this picture.

On April 26, 1937, in the Spanish town of Guernica, 1,654 people were killed and 889 were wounded—including many children. They were bombed and machine-gunned by German planes under Franco's orders. Picasso wanted to show the world this senseless slaughter. He worked feverishly for many weeks on this twenty-foot-long canvas. He used no color in this painting except black, gray, and white. Normally he loved vibrant color, but he felt such rage and grief that he couldn't use it here.

You can see that the painting is made from a jumble of shapes like broken glass. This style of painting is called *cubism* and was invented by Picasso thirty years before *Guernica* was painted. It gives the painting a ragged, cutting energy. Your eyes can never get too comfortable as they move across the picture. The artist

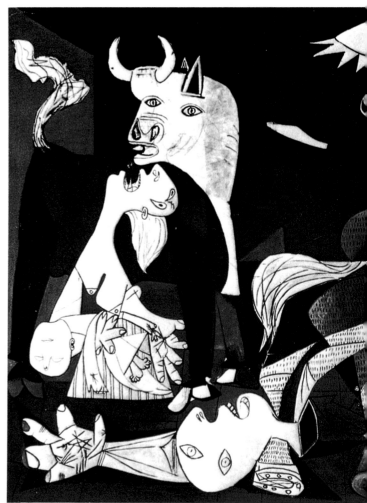

wants you to feel uneasy and distressed.

Guernica is full of details which tell a bloody story. The all-seeing eye of truth shines in the bare lightbulb. The horse screams with pain, a dagger thrust in its side. The bull, the symbol of Spain and Picasso's favorite animal, stares blankly out of the picture. Picasso has said that in this painting the bull represents brutality. There is agony everywhere. The world is shattered by war, and the "floor" of the picture is littered with broken lives.

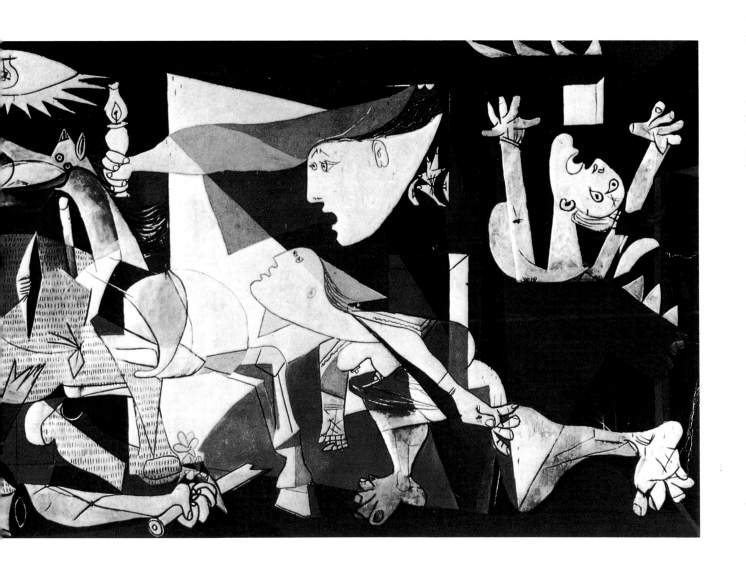

Exhibition of a Rhinoceros at Venice, 1751

PIETRO LONGHI

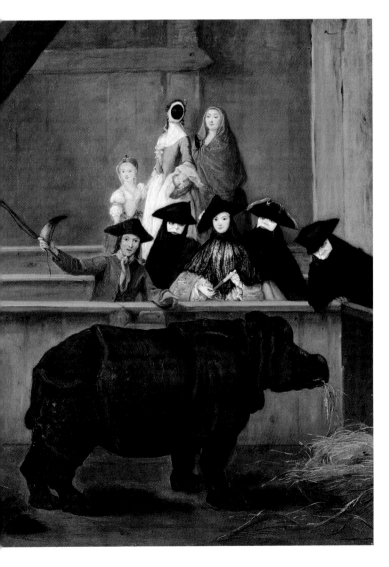

WITH HIS SON ALESSANDRO, PIETRO Longhi was one of the most observant painters of Venetian life. His pictures almost tell us more than books about the lifestyle of the wealthy aristocracy in 18th-century Venice. This picture captures the strange, nervy atmosphere of the city during Carnival, a wild, week-long feast (still celebrated today) marking the beginning of Lent in the Christian calendar. Wearing masks to hide their identity, carnival people are apt to act strangely, just like this cruel, well-dressed group of Venetians.

The tired old rhinoceros—a clumsy, exotic creature—has been imported from Africa for their pleasure. The poor animal has obviously suffered from his long sea voyage. His skin is dull and his tiny eye is lifeless. There is a sad element in this picture that makes me think that Longhi doesn't like these people very much. The dark, ugly, lumpy, fleshy folds of the poor animal contrast with the delicate features of the frivolous young woman who ignores the animal's suffering as she taps her silk fan against her white kid glove. The young man holds a whip in his raised arm, ready to strike the helpless animal. To me, this picture is a comment on how cruel human beings can be to animals.

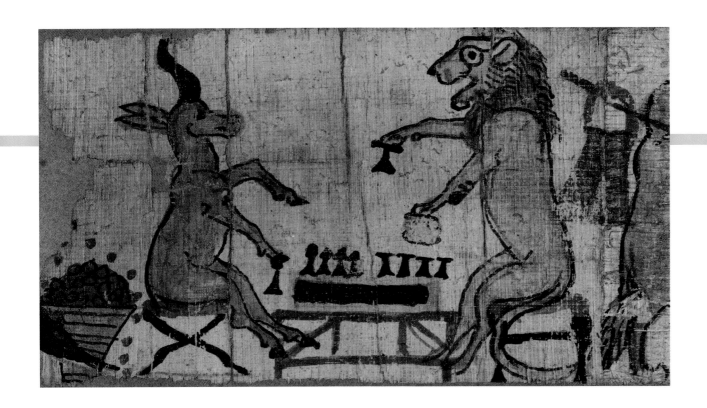

A Lion and Antelope Play Senet, 1250–1150 B.C.

EGYPTIAN PAPYRUS

THE ANCIENT EGYPTIANS BELIEVED THAT after people died, they would need many things to take with them on their journey to the next world, the Afterlife. Archaeologists have discovered many precious ornaments in the tombs of the Egyptian rulers, or Pharaohs.

In addition to gold and jewelry, important people were sometimes buried with a book known as a *Book of the Dead,* which reflected their activities on Earth. These books were always painted on *papyrus,* a strong form of paper woven from the delicate stems of water reeds found on the banks of the Nile River. In rare cases, a person was buried with an amusing or satirical papyrus, like this one. Here the artist (or *outline scribe,* for the Egyptians had no word for artist) has painted animals playing out the human game of senet, an ancient board game. The lion certainly looks as though he is winning against his opponent. An antelope can run much faster than a lion, so the point of the picture may be that thought and intelligence can outwit speed and grace.

Perhaps this papyrus is a joke about the competitive spirit and cunning of its owner in the Afterlife. Maybe it is the first political cartoon in history!

The Jungle: Tiger Attacking a Buffalo, 1908

HENRI ROUSSEAU

ROUSSEAU IS BEST KNOWN AS *LE Douanier* Rousseau, which means "the customs officer." Before he began painting at the age of forty-two, he had worked as a toll officer in Paris, checking on who and what passed into the city through its many gates. His first attempts at painting were laughed at by the sophisticated Parisian art world. But then, as now, he also had his fervent admirers.

Rousseau had not been schooled in art, and his untrained enthusiasm was refreshing to many more sophisticated artists, including Picasso (pages 34–35). In this picture, which looks as though it had been painted on an exotic safari to deepest, darkest Africa, Rousseau used sketches he made in the hothouse conservatories of the Jardin des Plantes, a botanical garden in Paris. The abundant bananas, the vicious tiger, and the flattened buffalo are all products of a vivid imagination, aided by photographs of wild animals purchased from Rousseau's local department store, the Galeries Lafayette.

For such a gentle man, Rousseau's paintings often contained an element of deep, secret violence. The meek and mild customs officer felt that he had a wild beast trapped inside him, and art was his escape from a dreary existence. Rousseau was arrested for fraud and forgery the year after this picture was painted, and he was sentenced to two years in prison. His sentence was suspended, and he resumed his life and his painting. Perhaps life wasn't too dreary after all.

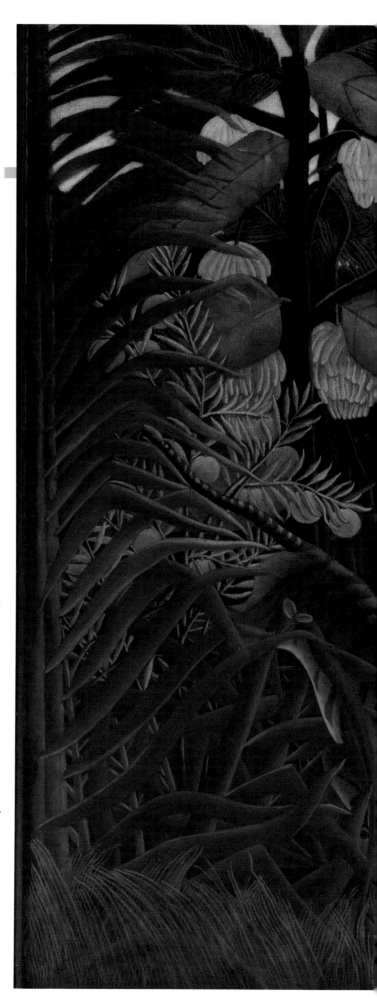

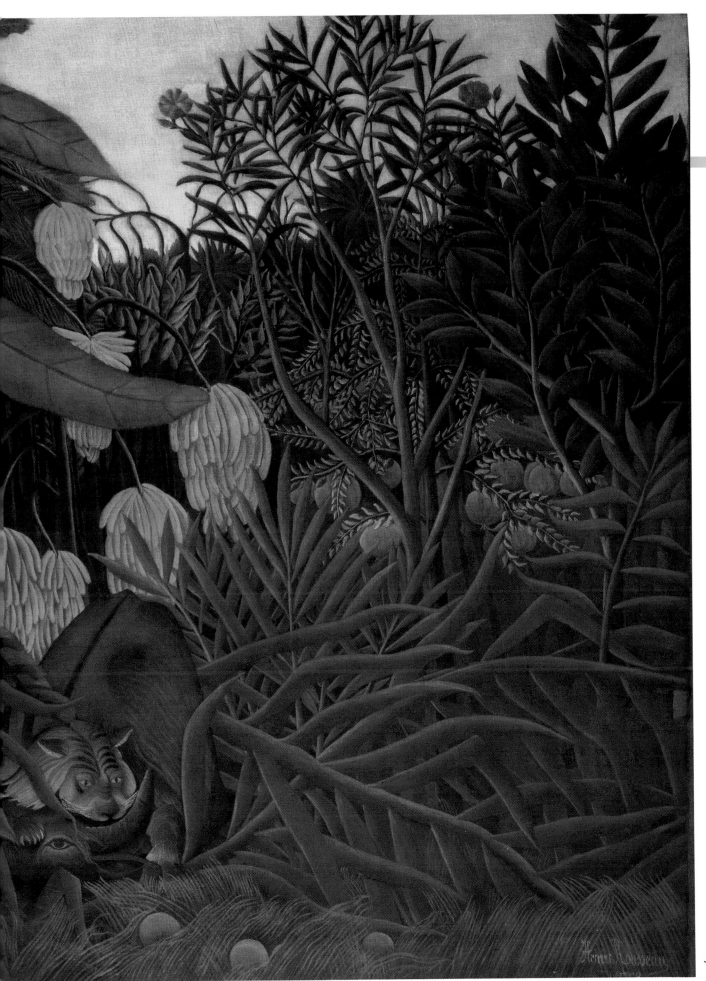

V. MAKING PICTURES

The Forest Tapestry (detail), 1887

WILLIAM MORRIS

LIKE THE ARISTOCRATIC SEAMSTRESSES WHO carefully labored over the tapestry of *The Lady and the Unicorn* (page 19), William Morris believed in the marriage of beauty and usefulness. In fact, this was the most important aspect of his artistic philosophy.

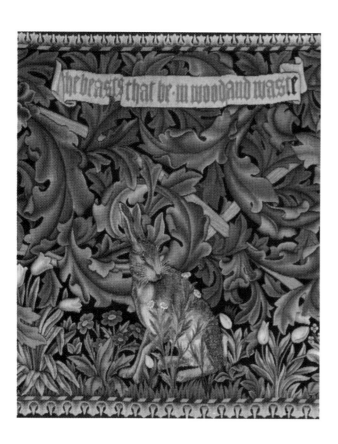

In 1861 he founded a business called Wm. Morris and Co. in order to produce decorative pieces that people needed in their homes. He designed wallpaper, furniture, and carpets. His designs are still firm favorites of many people today and are still produced in small, expensive quantities. (He would have hated this because he believed that good design was fit for everyone, no matter how rich or poor.) William Morris disliked the dark, gloomy heaviness of the art of his time, known as Victorian art (named after the reigning queen, Victoria).

Morris loved the bright clear colors of late medieval art, like those in *The Lady and the Unicorn* tapestry (page 19). He loved tales of Arthurian England, of knights and fair damsels, and he loved animals as well. But his hare, made from hundreds of small woven stitches, is not stylized like the little rabbit on the carpet of flowers by the lion's feet in *The Lady and the Unicorn.* Nor is it cuddly like Beatrix Potter's Peter Rabbit (opposite). It is quite realistic—more like the nature studies of Merian, Le Sueur, and Ligozzi (pages 13-15).

Design for "The Tale of Peter Rabbit," 1902

BEATRIX POTTER

THE TALE OF PETER RABBIT IS ONE OF MY favorite books, and my children have been brought up on these tales of naughty bunnies too. I like the pictures in the books best because Beatrix Potter's animals are always so full of mischief and personality. She made very careful watercolor and pencil studies of live animals before creating the illustrations for her stories. With her light, informal style of painting, this knowledge of animals gives her characters their strength and naturalness. Her animal heroes and heroines are very real, but are quite different from the nature studies of Hokusai (page 12) or Merian (page 13). Beatrix Potter has a tale to tell.

This scene comes at the moment in the book when Peter rushes home from Mr. McGregor's garden and his mother puts him to bed with camomile tea: "One tablespoon to be taken at bedtime." The picture shows her making the tea for Peter, who is tucked up in bed in the background.

This is the original watercolor painting of one of the illustrations in a book that has been reproduced millions of times, in hundreds of different languages, making Peter Rabbit a hero to children all over the world.

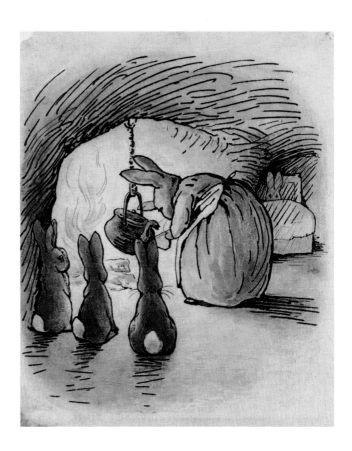

Tlingit Button Blanket, late 19th century

NATIVE AMERICAN ARTIST UNKNOWN

MᴵᴸᴸᴵᴼNS ᴼF ᴇxQᴜᴵSᴵᴛᴇ SᴛᴵᴛᴄHᴇS WᴇNᴛ into the creation of *The Lady and the Unicorn* (page 19), but this picture has been sewn in a different manner—with buttons made of mother-of-pearl and carved from seashells. The buttons have been sewn onto a traditional woolen blanket used by the Tlingit tribes of Western Coastal Canada. The tribespeople traded blankets for other goods, like the buttons, without money changing hands, in a system called barter.

This frog was probably the crest of an important chief, or person of high rank. The blanket would have been worn on his back. It's amazing how the artist has made such a strong image—visible from a long distance—with only three colors.

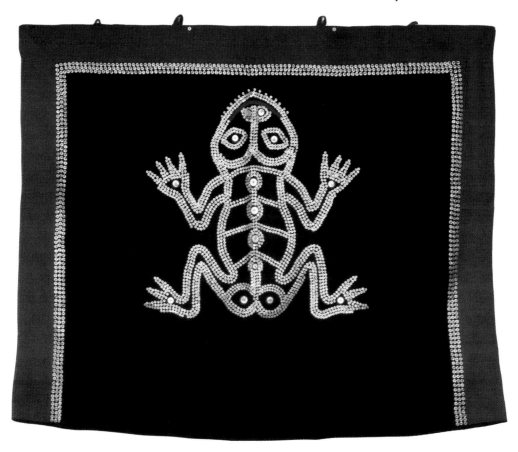

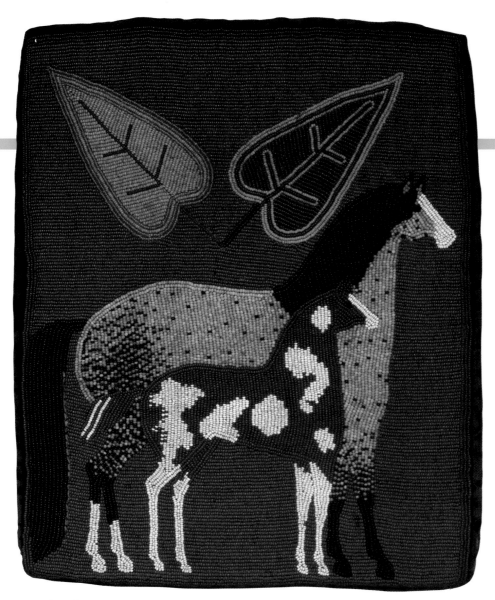

Yakima Beaded Bag, early 20th century

PLATEAU BEADWORKERS

HERE IS YET ANOTHER WAY OF MAKING A picture—with tiny glass beads sewn very carefully in horizontal lines. The artist worked closely from a prepared drawing, because this picture-making form requires that you count the number of beads of each color in each row, rather like knitting and purling a sweater. A mistake could mean that the horse ends up without a hoof, or with too few spots!

This picture shows two kinds of horses bred by the Plateau Indians—the brown-and-white spotted Pinto and the gray Appaloosa breeds. I love the strong, simple shapes of these horses. They remind me of the very earliest paintings of horses—sketched in Paleolithic times on the walls of the caves at Lascaux, France (page 16).

Marrany Wirntikirli, 1987
JIMMY PIKE

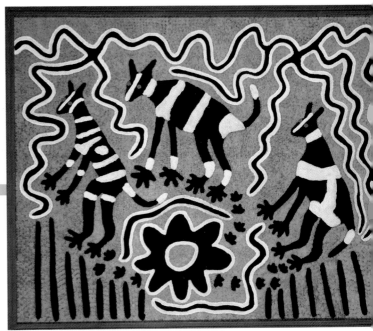

THE ABORIGINAL PEOPLE OF AUSTRALIA are the original inhabitants of this vast continent, much like the Native Americans in the United States. Their homeland might appear a harsh place to other people—a land of desert with little vegetation and water—but they have a deep and satisfying relationship with the land and its ancient history. They believe in an ancestral past that they call the "Dreamtime," which links them to their forebears. The Aborigines believe that no one can own the land but that all people belong to the land. Their paintings celebrate the Dreamtime and are often painted in colors mixed from the minerals in the earth. The colors, designs, and textures used in the paintings are very strong and attractive to look at. The works of Aboriginal artists are now collected widely in Australia and throughout the world.

Many Aboriginal pictures depict the animals that they love and depend upon in their daily lives, as well as the animal legends about the beginning of the world from the Dreamtime. Many paintings are far older than the cave paintings from Lascaux (page 16). Some have been dated to 30,000 years ago—a very long time in the history of art.

The tradition is still very strong. In 1987, Aboriginal artist Jimmy Pike describes his wonderful painting of dingoes like this: *"Dingo from Dreamtime. People want meat. They rub the rock and talk to it, ask for dingoes to come out, small ones, not big ones, for meat. They are black and white ones from there, from Jupurr."* His words are as sharp and graphically descriptive as his drawing of the black and white dingoes themselves.

Akbar Hunting with Cheetahs near Agra, c. 1600
BASAWAN AND DHARM DAS, FROM THE AKBARNAMA OF ABUL FAZL MUGHAL

IN THE 16TH CENTURY, A NEW MOSLEM dynasty of central Asia invaded India. They became known as the Mughals, which is a corruption of the word, "mongol," a name for the people of Mongolia. The first Mughal Emperor, Babur, came to the throne in 1526 and was descended from the famous Jenghiz Khan, better known as Genghis Khan, and Timur-l-leng, or Tamburlaine.

Young Emperor Akbar, the subject of this picture, was Babur's grandson. He came to the throne in 1556, when he was